PHOTO DOODLES

GRAFFITI

A COMPLETE-THE-PHOTO CREATIVE DRAWING BOOK

Designed by Heather Zschock

PETER PAUPER PRESS, INC.

White Plains, New York

PETER PAUPER PRESS
Fine Books and Gifts Since 1928

In 1928, at the age of twenty-two, Peter Beilenson began printing books on a small press in the basement of his parents' home in Larchmont, New York. Peter—and later, his wife, Edna—sought to create fine books that sold at "prices even a pauper could afford."

Today, still family owned and operated, Peter Pauper Press continues to honor our founders' legacy of quality, value, and fun for big kids and small kids alike.

Graffiti art by David Cole Wheeler: covers, pages 1, 2, 3

Images used under license from Bigstock.com: cover backgrounds, endsheets, background page 3, pages 4-5, 8, 9, 14-15, 18, 19, 20-21, 26-27, 30-31, 37, 38, 39, 46-47, 48-49, manhole 52, 54, 56, 57, 59, 62-63, 64-65, 74, 75, 76-77, 80-81, 82-83, 84-85, 86-87, 90-91

Images used under license from Shutterstock.com: pages 6-7, 10-11, 12-13, 16, 17, 20-21, 22-23, 24-25, 28-29, 32, 33, 34-35, 36, 40-41, 42-43, 44-45, background 50-51, background 52, 53, 55, 58, 60-61, 66-67, 68, 69, 70-71, 72-73, 78, 79, 88-89, 92-93, 94-95, 96

Published in the United Kingdom and Europe by
Peter Pauper Press, Inc., c/o White Pebble International
Unit 2, Plot 11 Terminus Road
Chichester, West Sussex PO19 8TX, UK

Printed in China
7 6 5 4 3 2 1

Visit us at www.peterpauper.com

ART=PLAY

Plunge right into this cool collection of photos to complete any way you want. Take up pen, pencils, markers, crayons—whatever works—put on some loud music, and have your way with it. Complete and transform each image with your own subversive style and artistic vision. Create lettering styles to suit your messages, and rock the scenes with your trademark artwork. Let this cool and captivating collection set your imagination free!

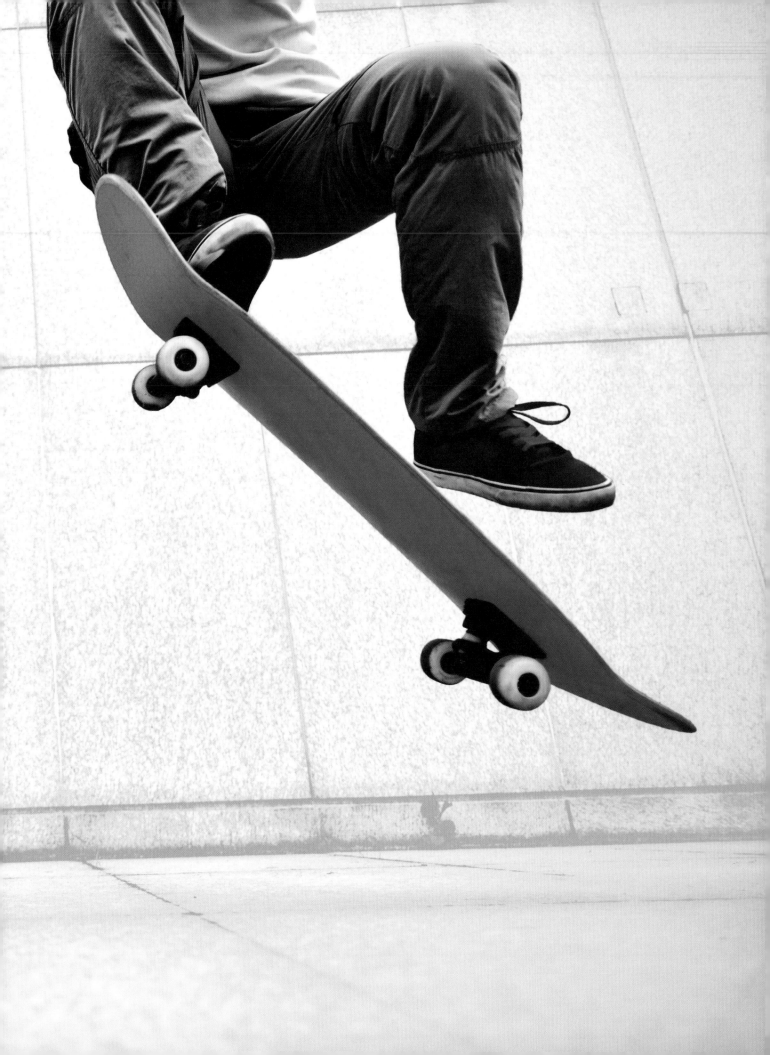

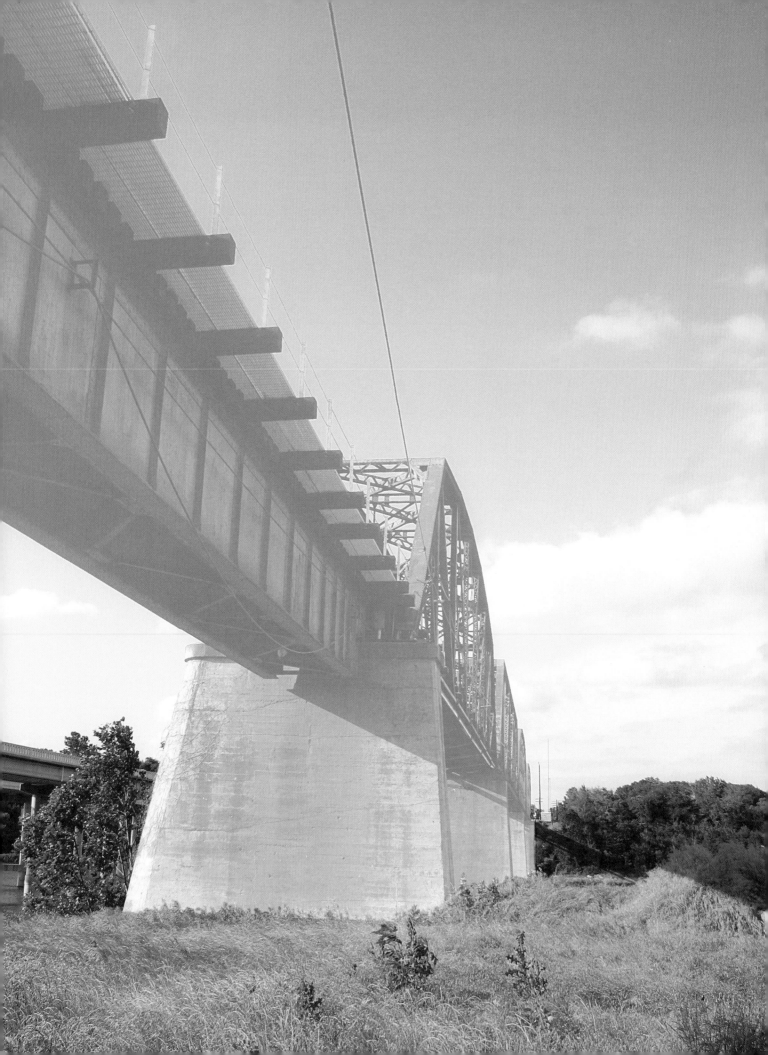

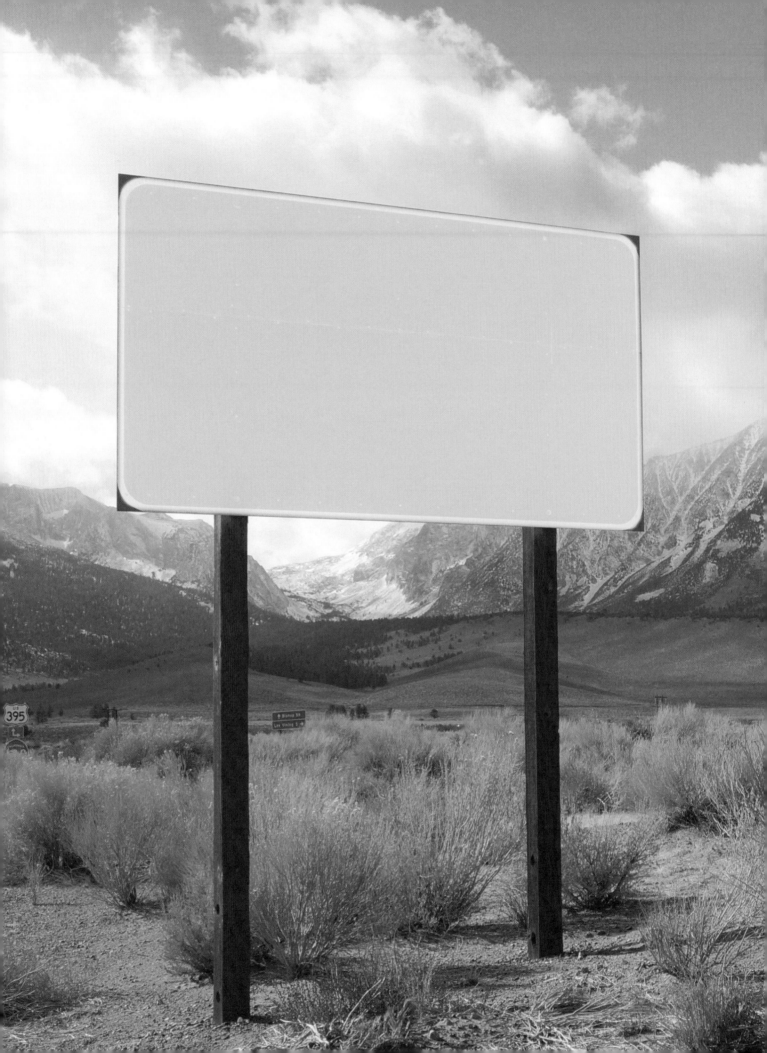

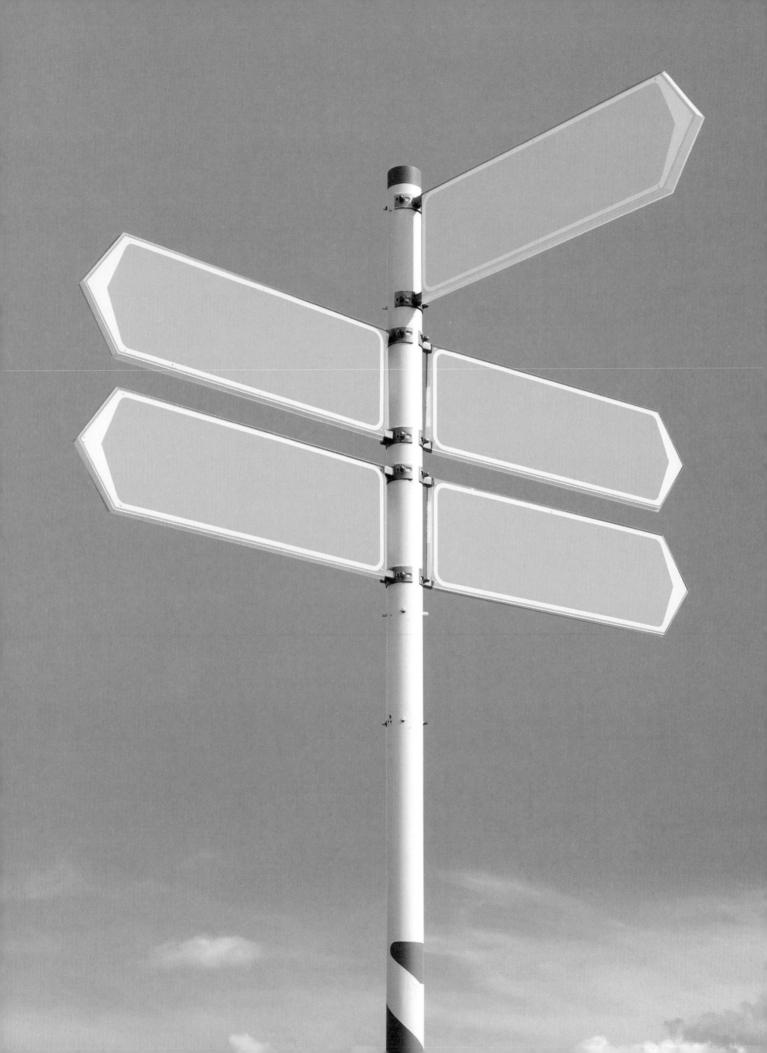

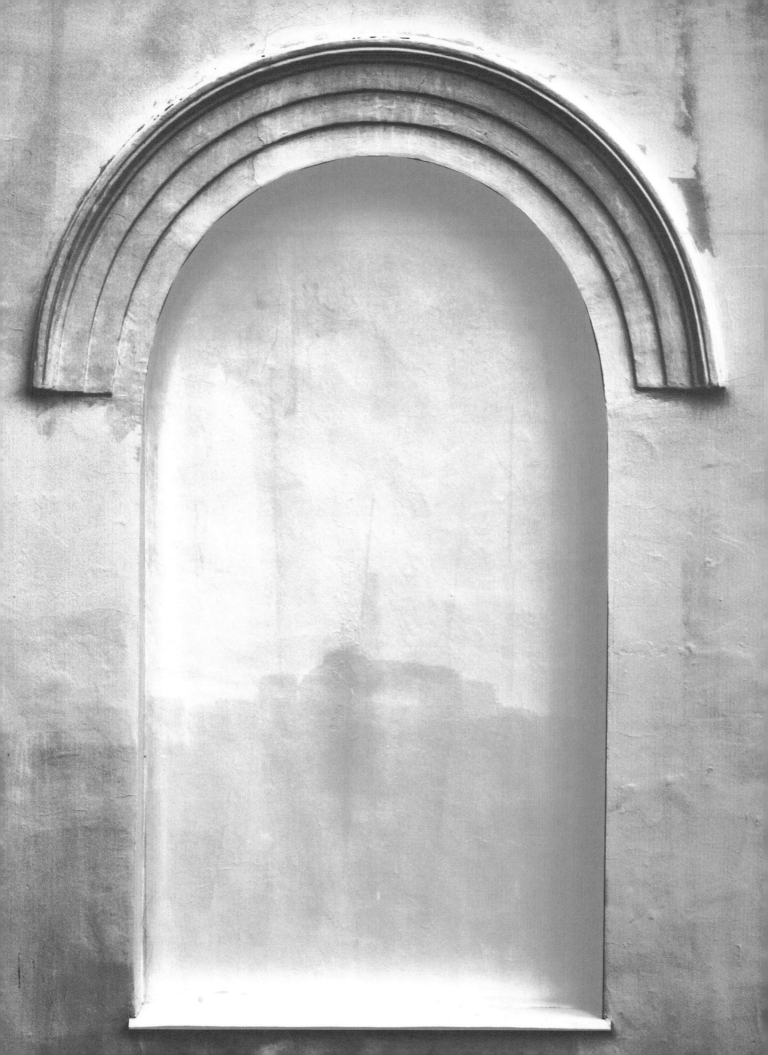

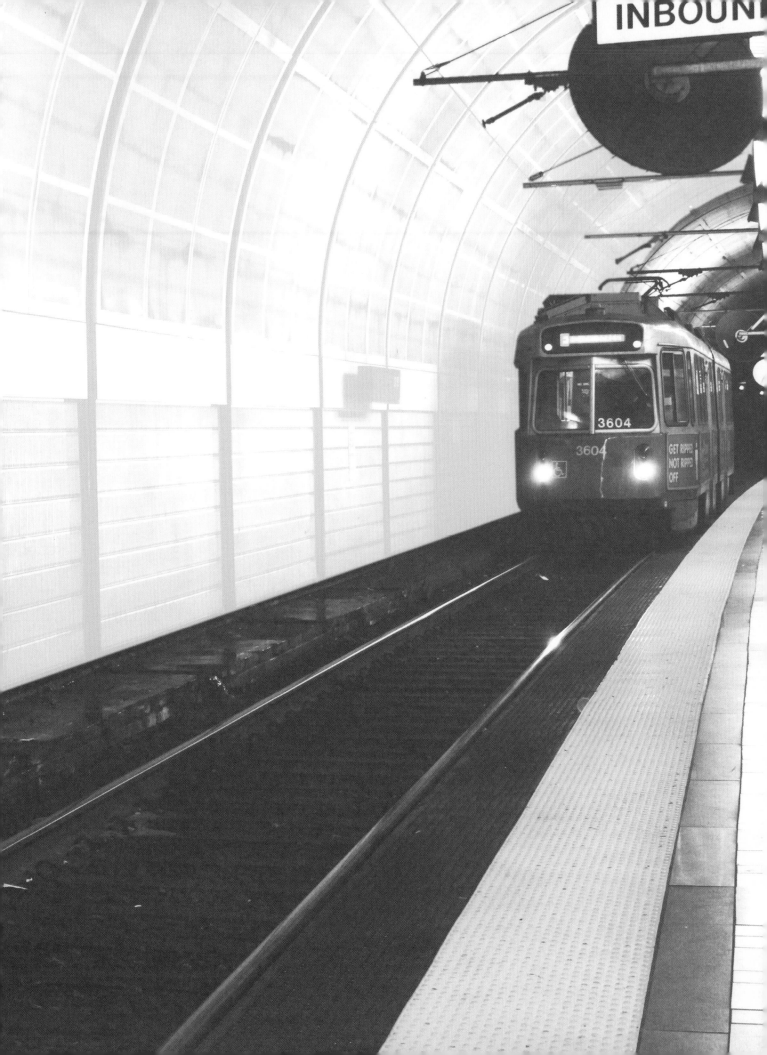

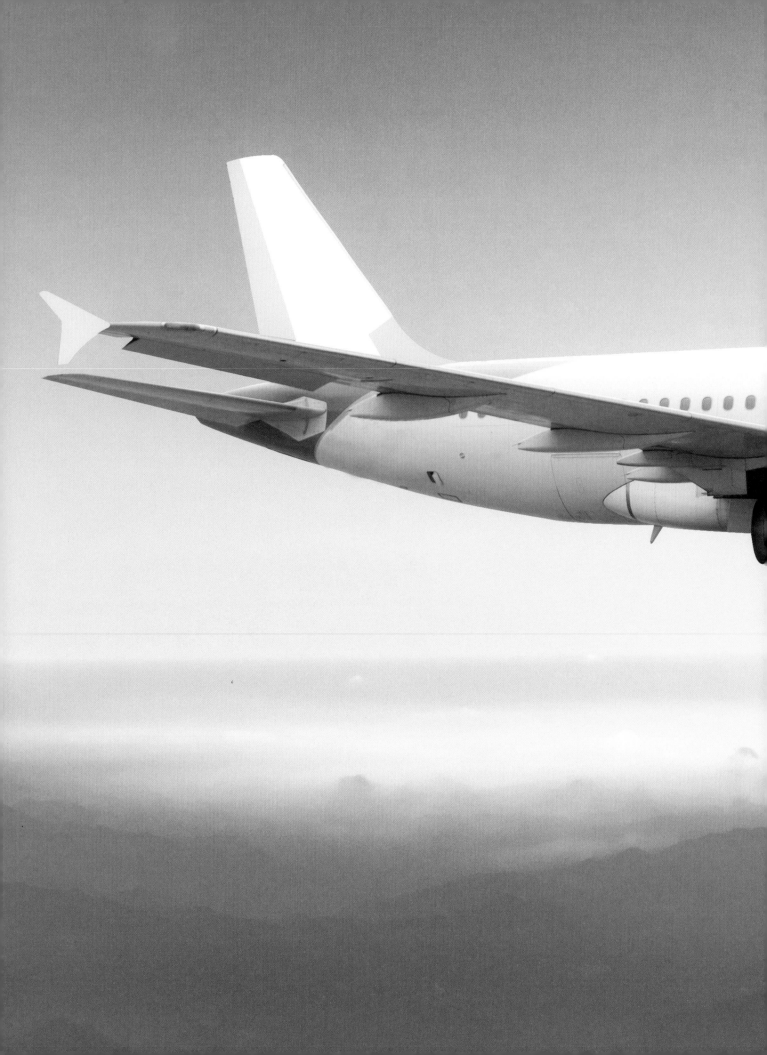

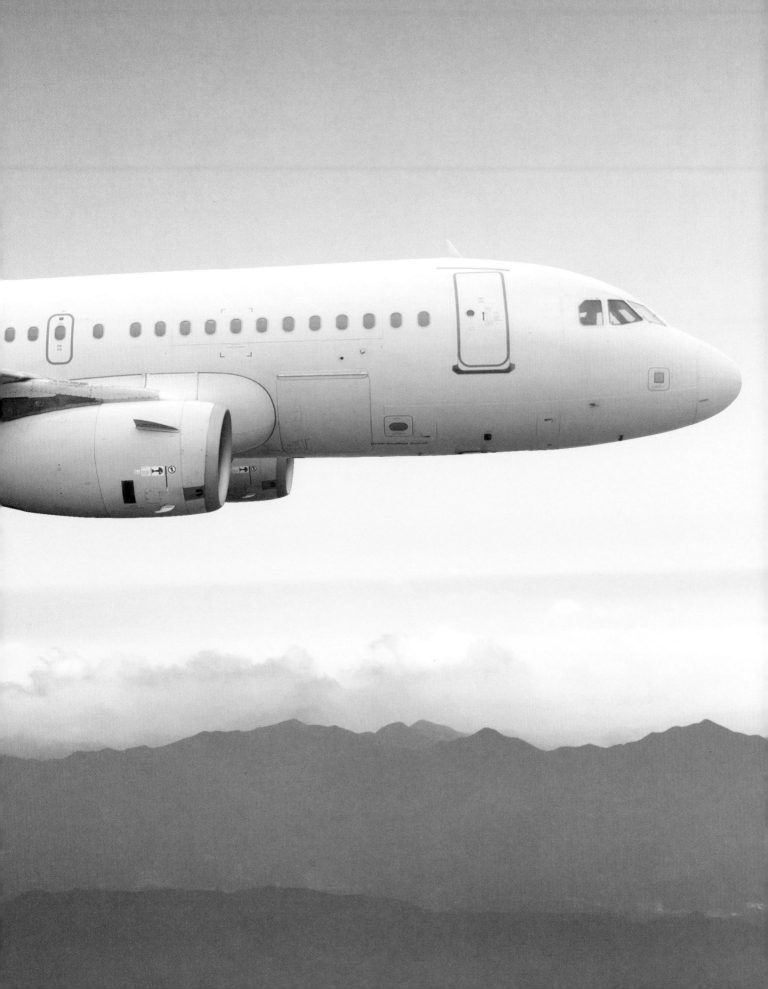

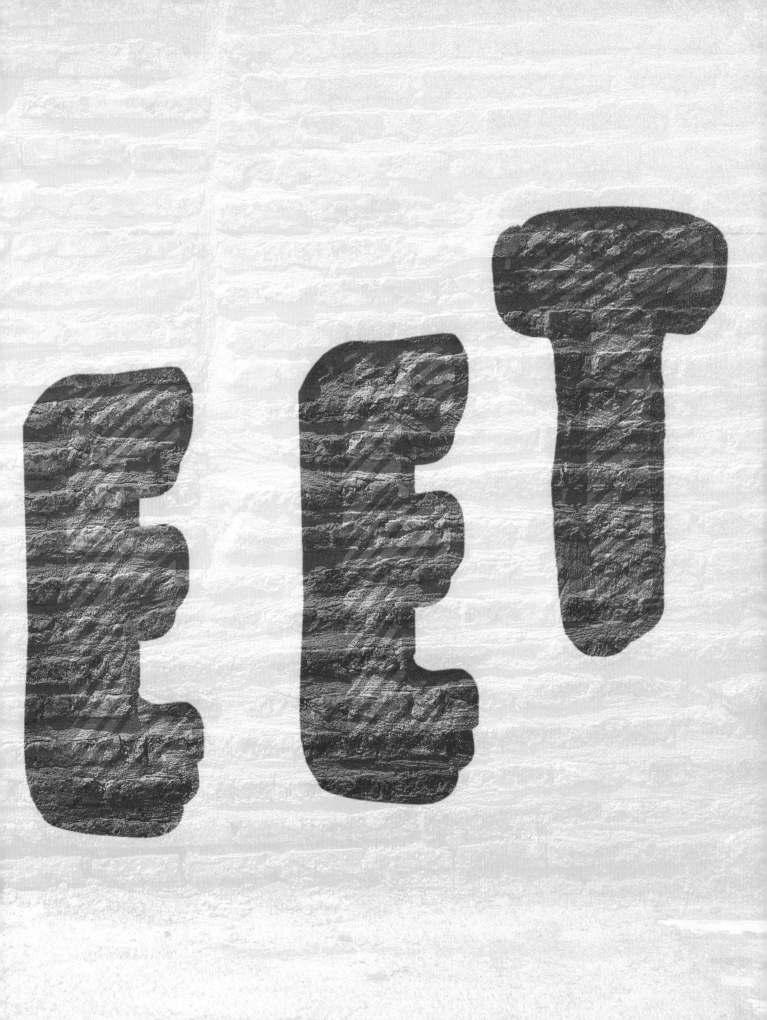

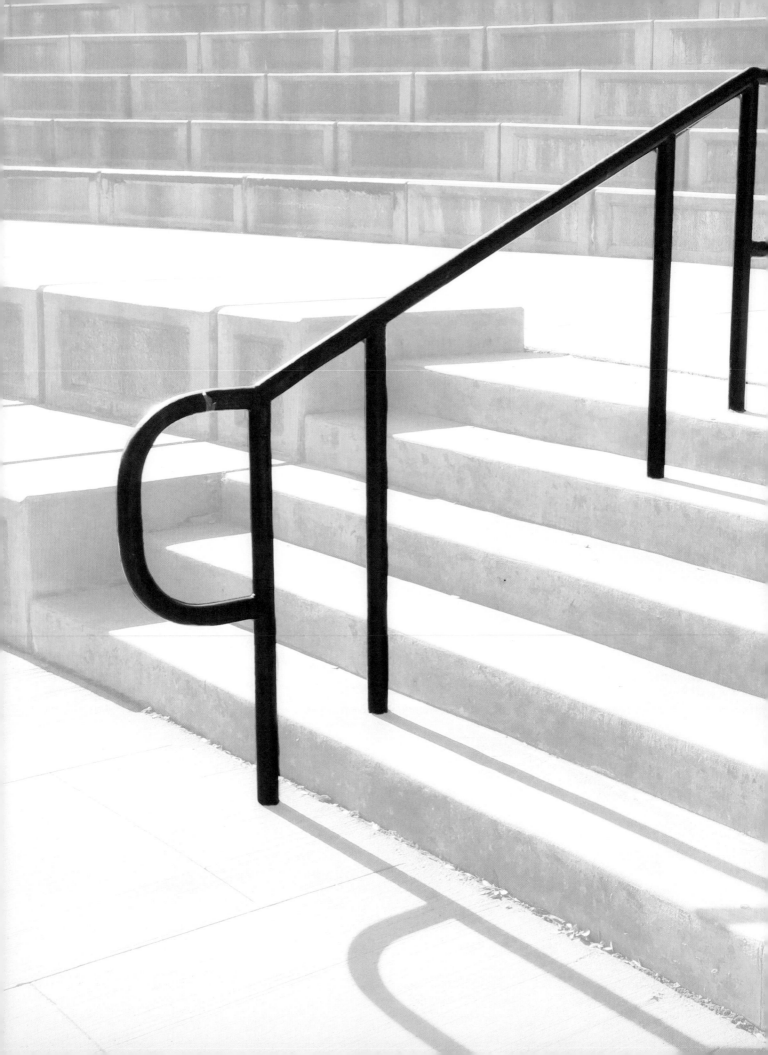

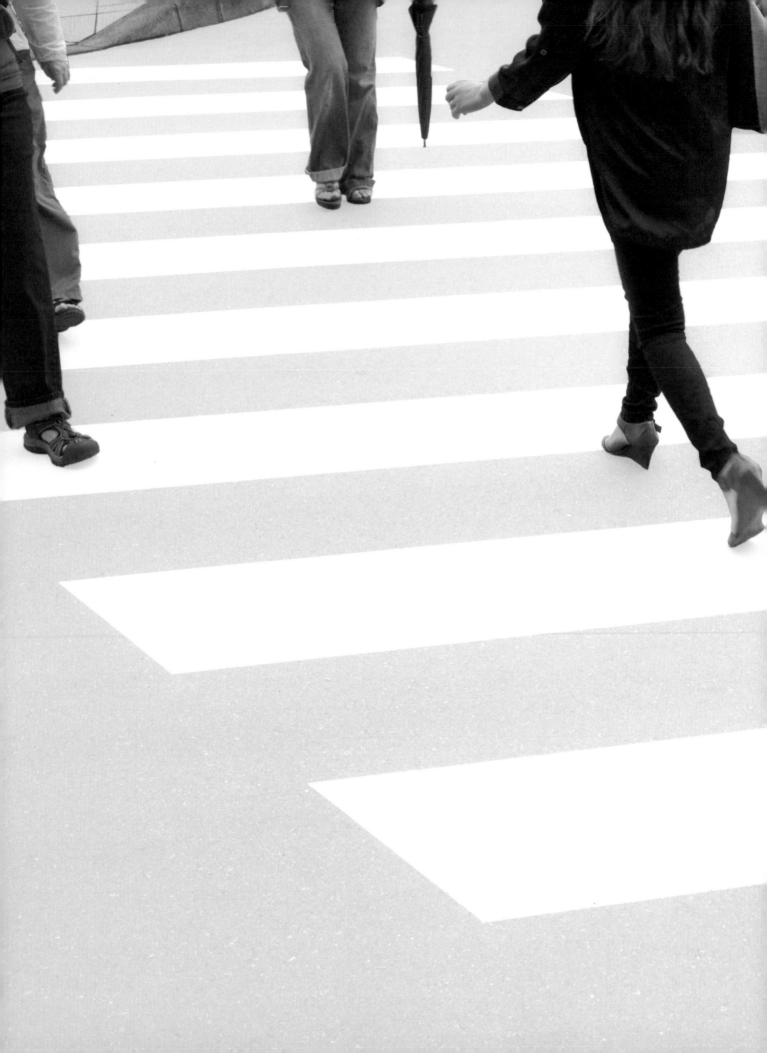

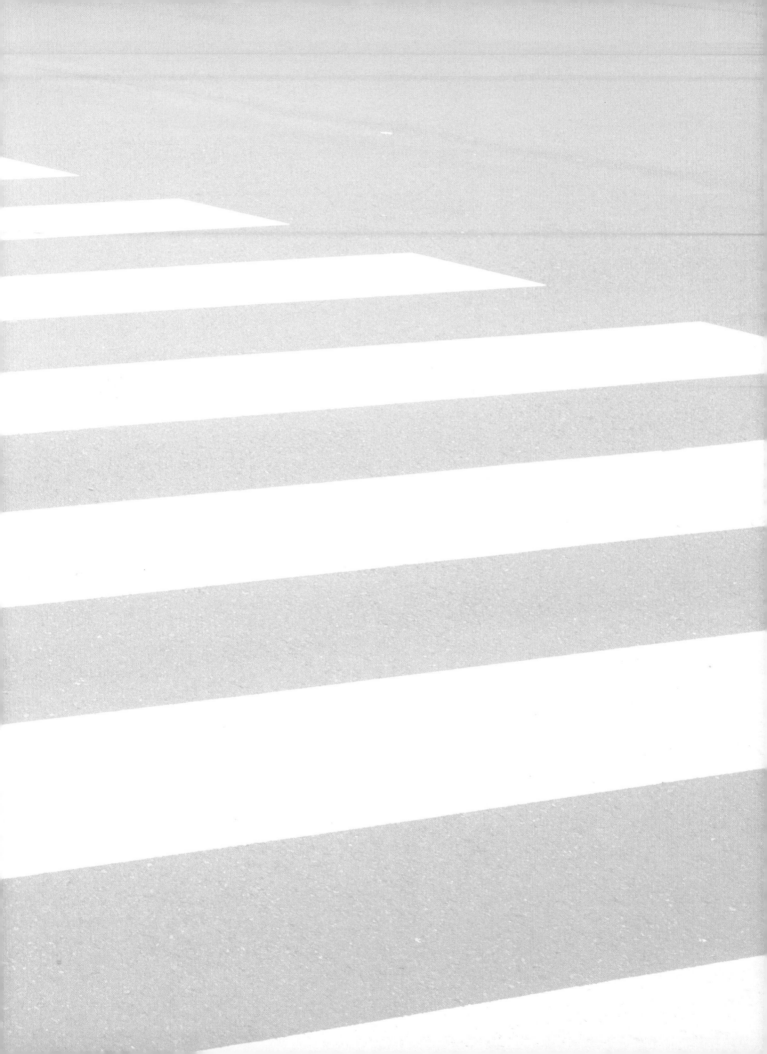

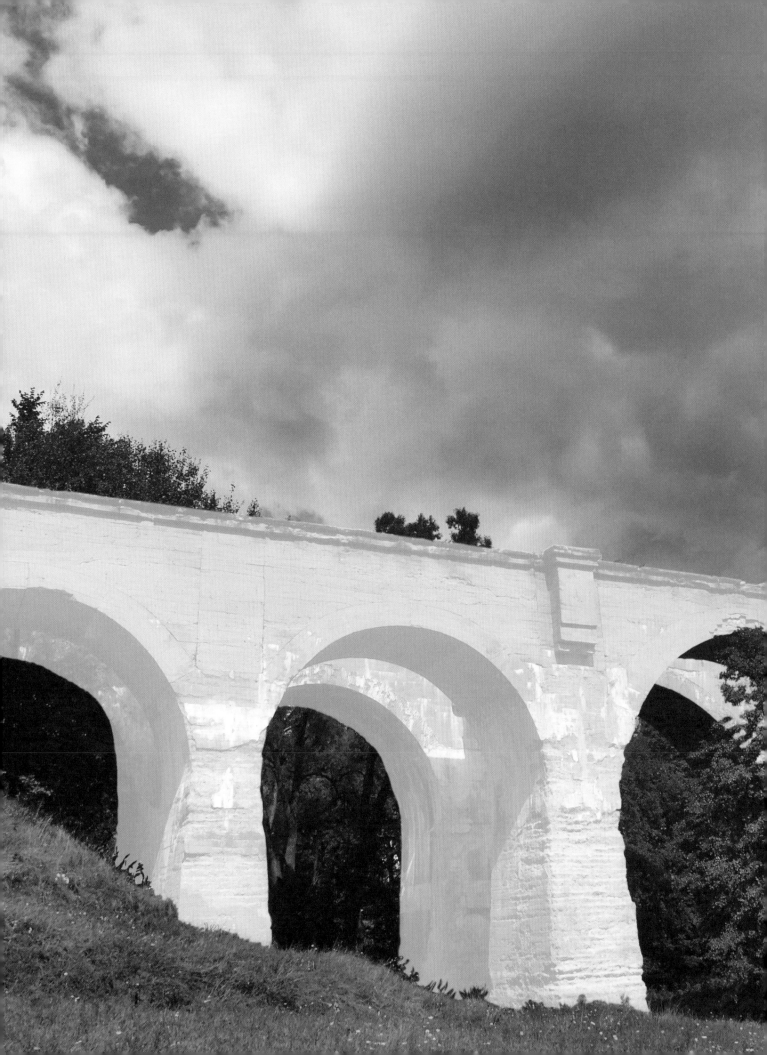

 Elevator to Street →

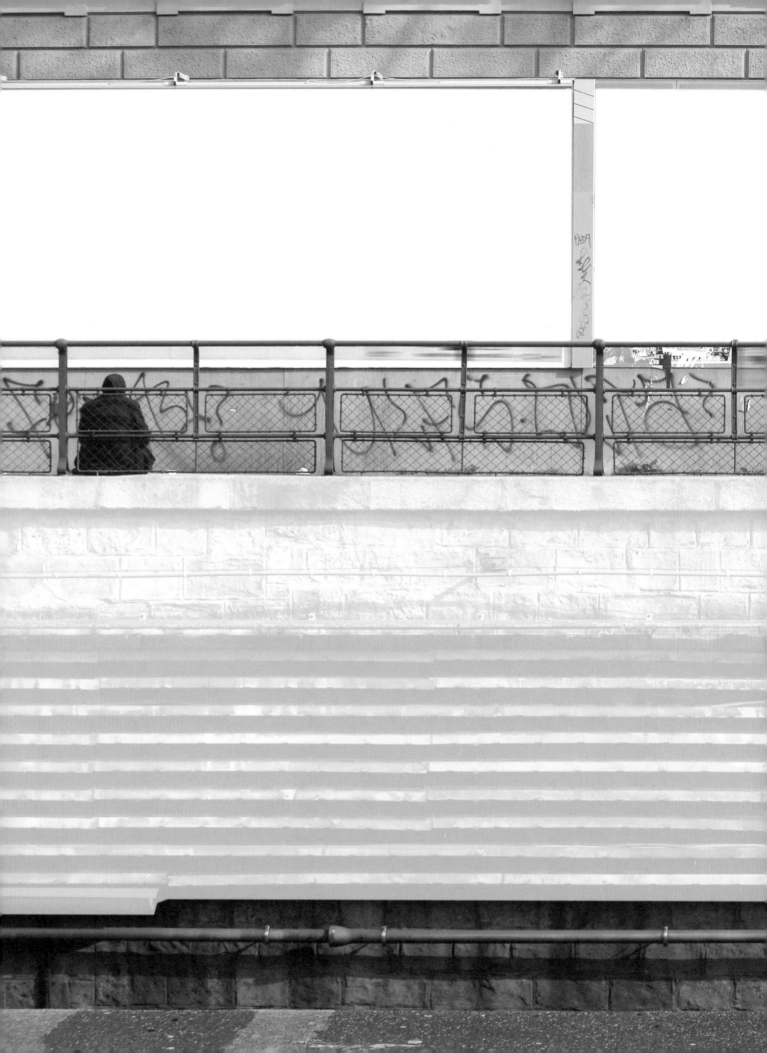

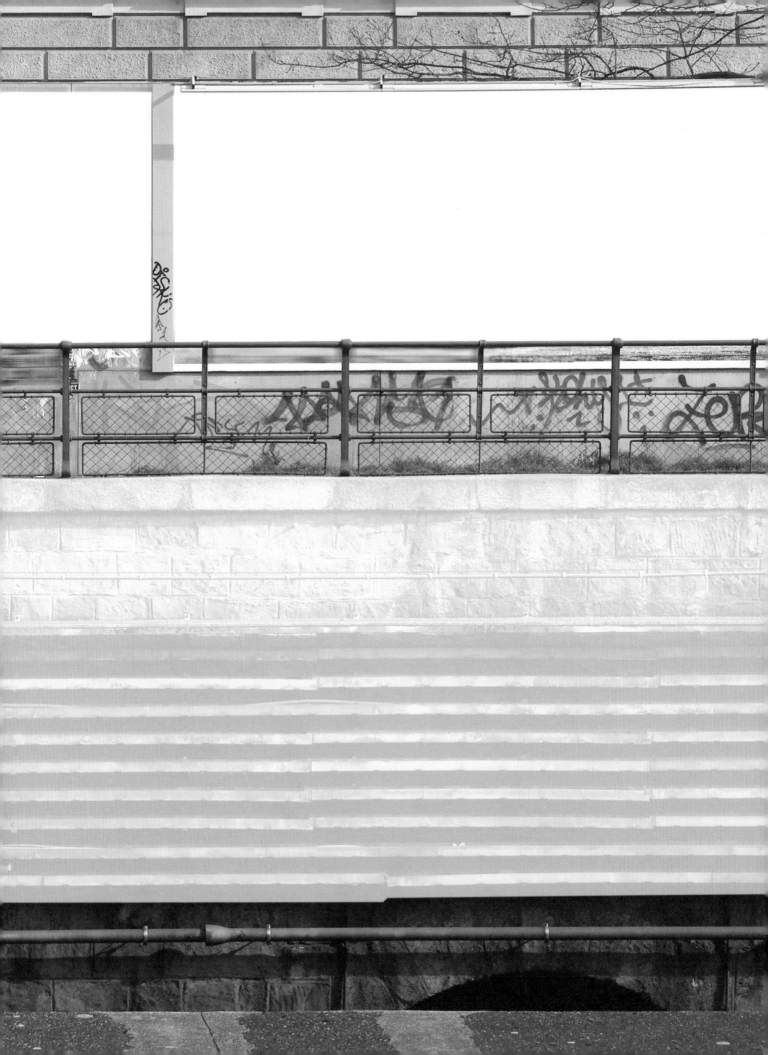

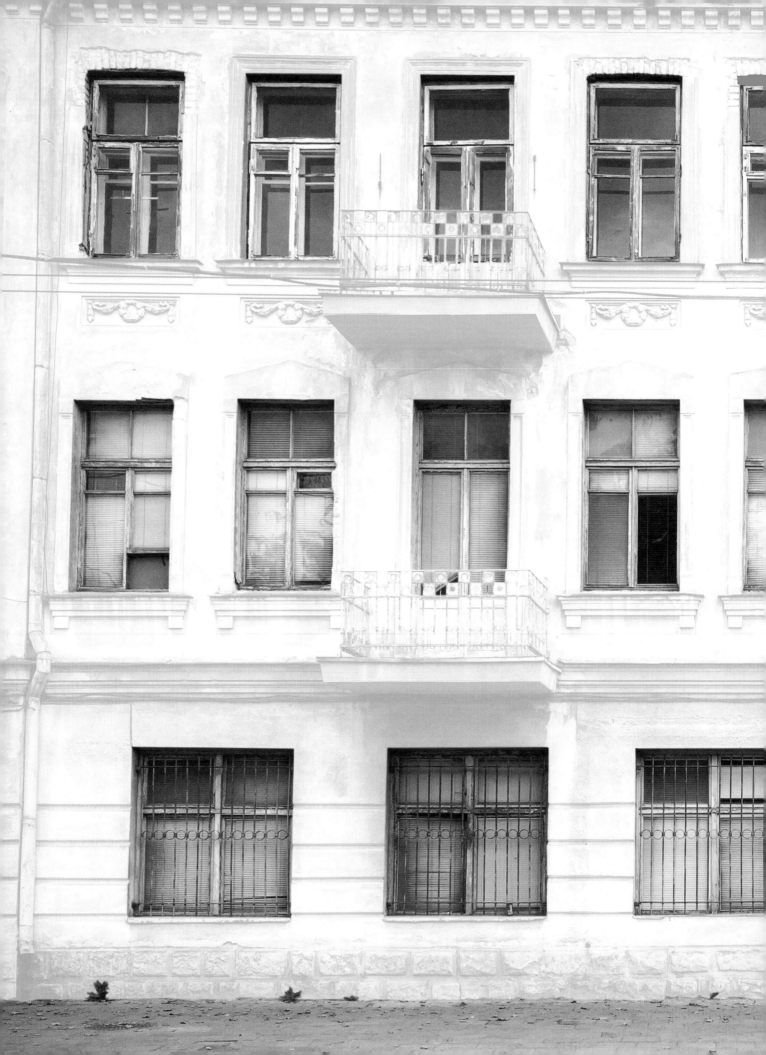

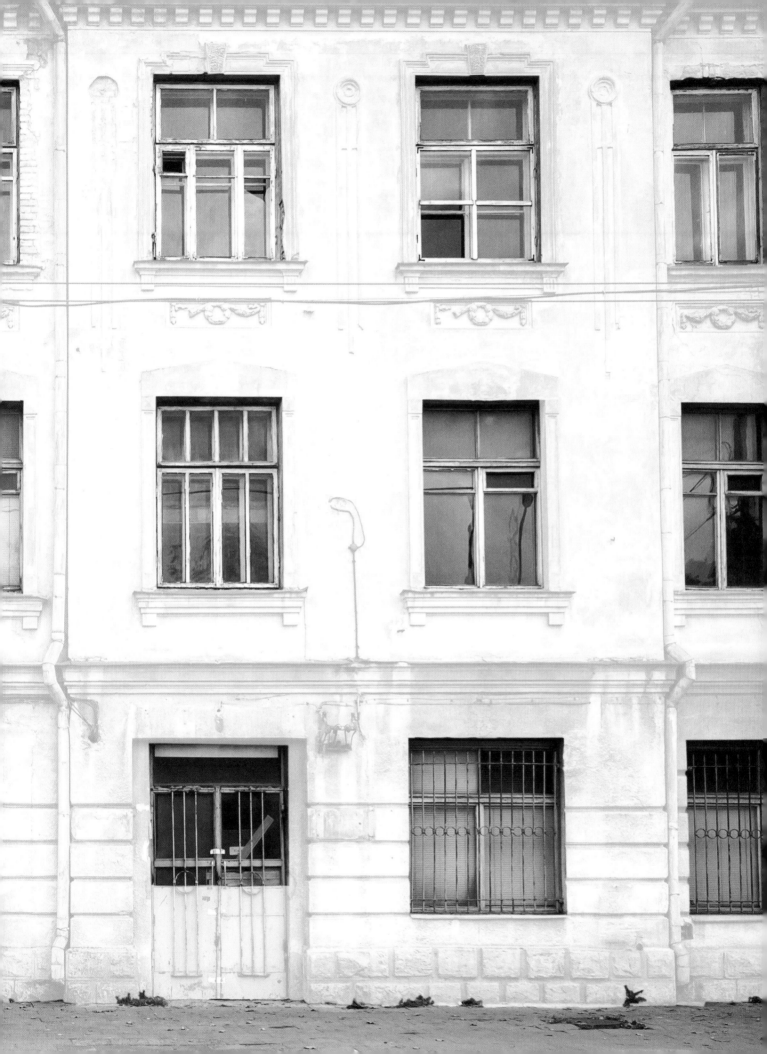

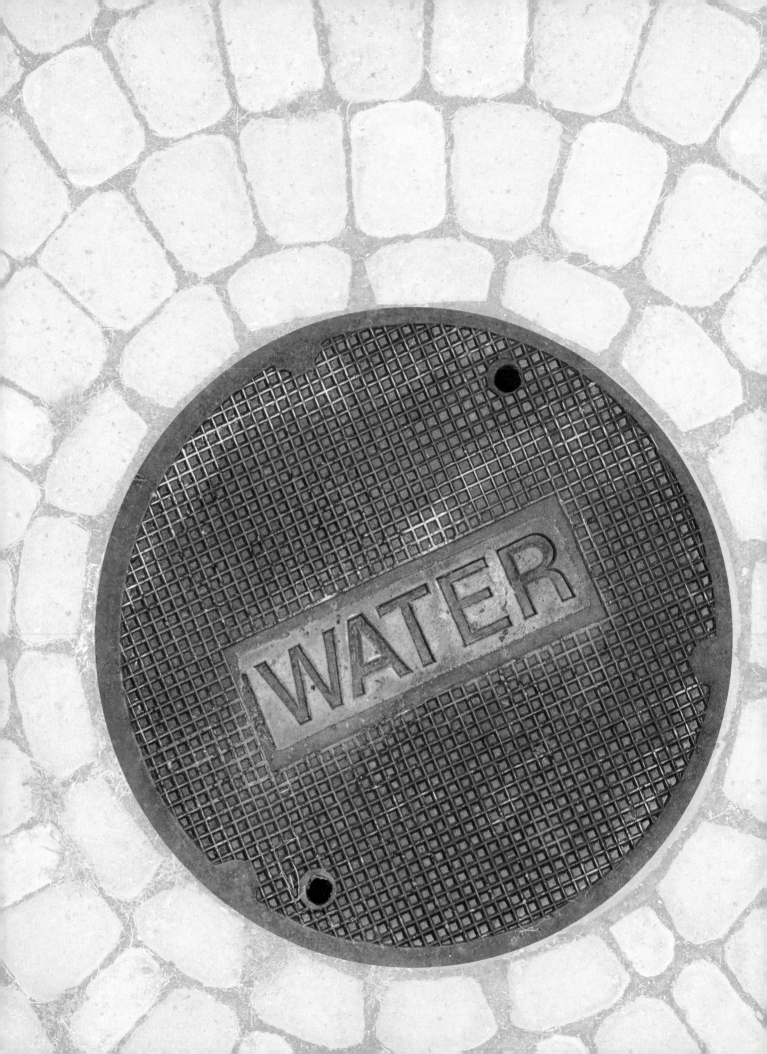

TICKETS

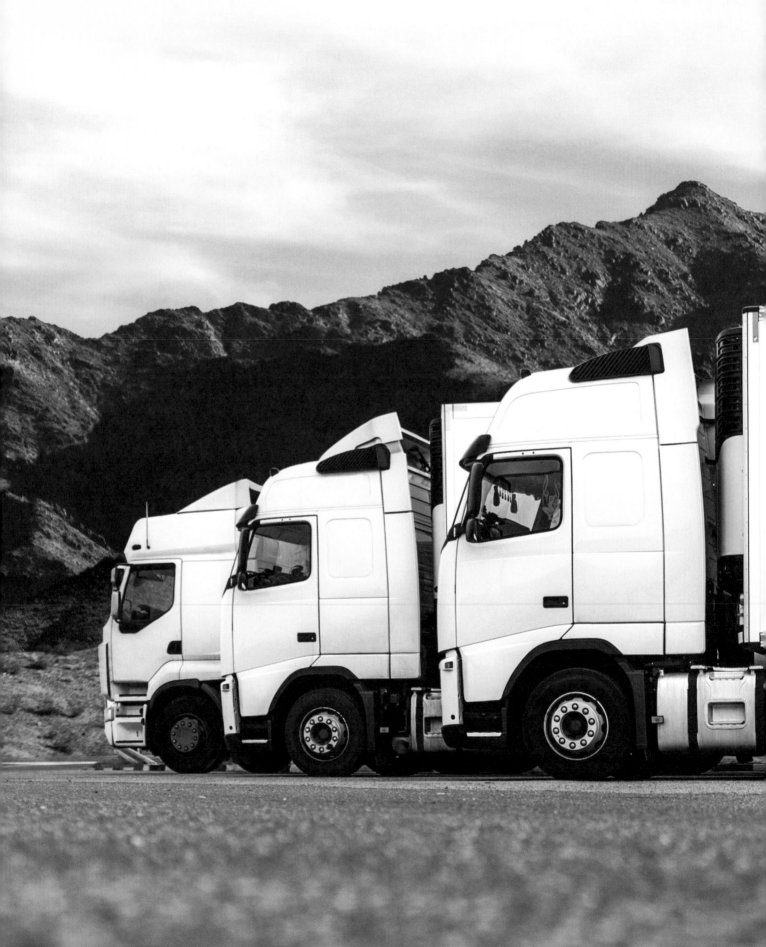

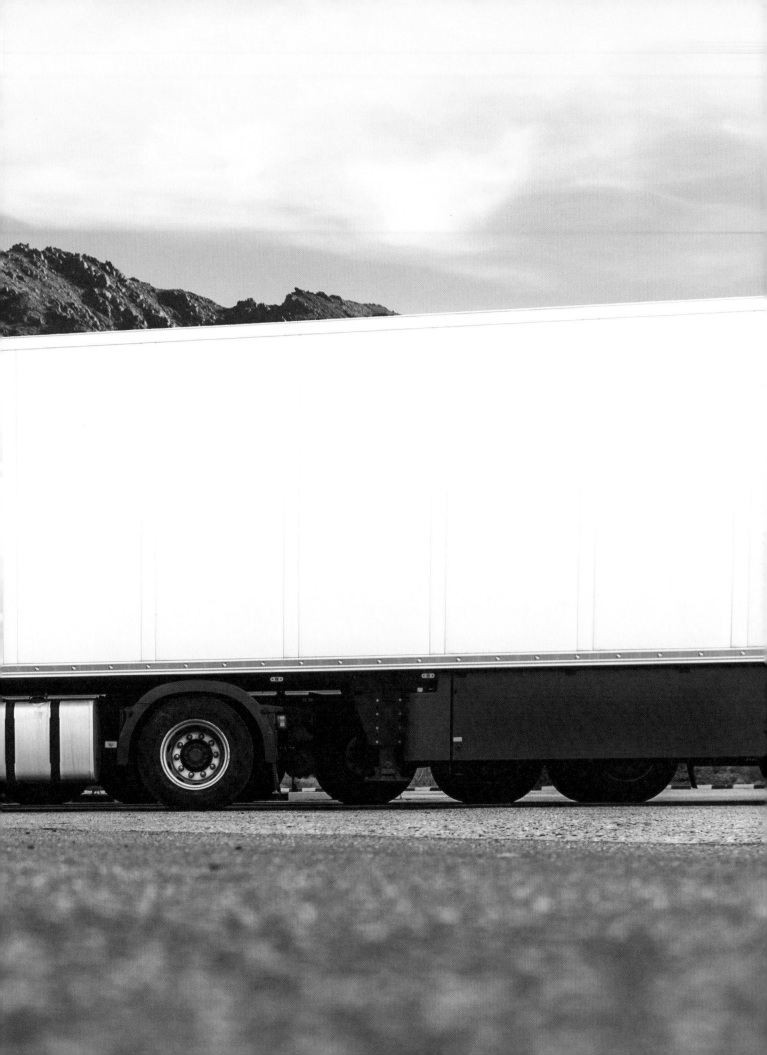

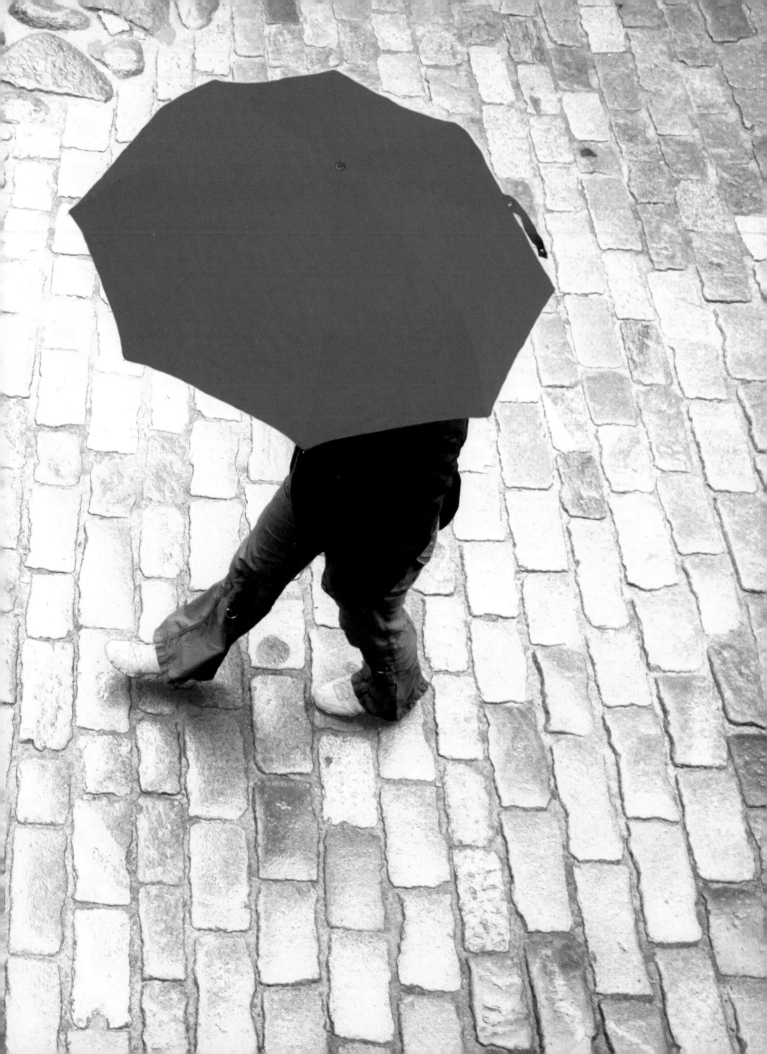

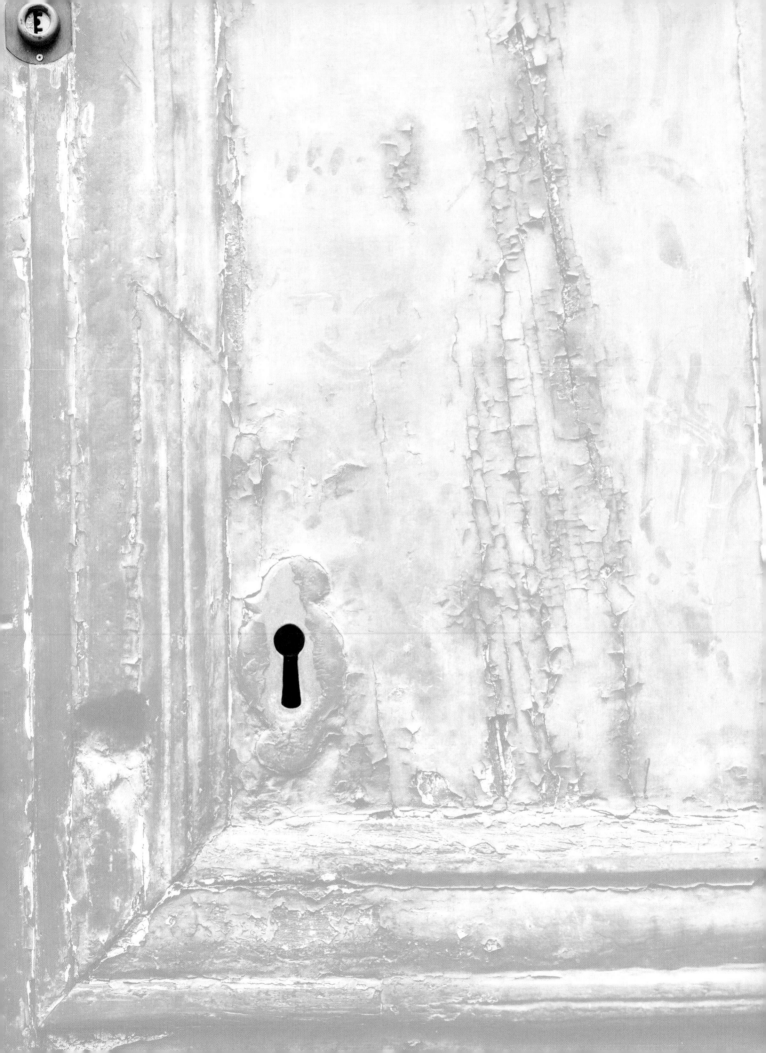

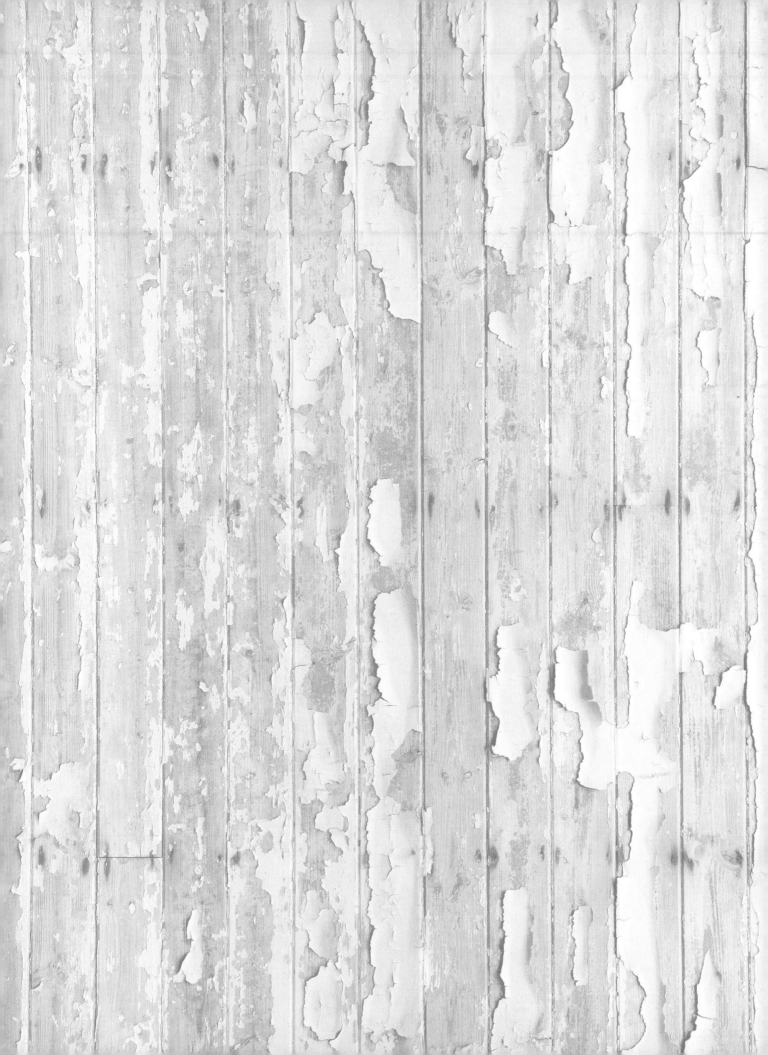

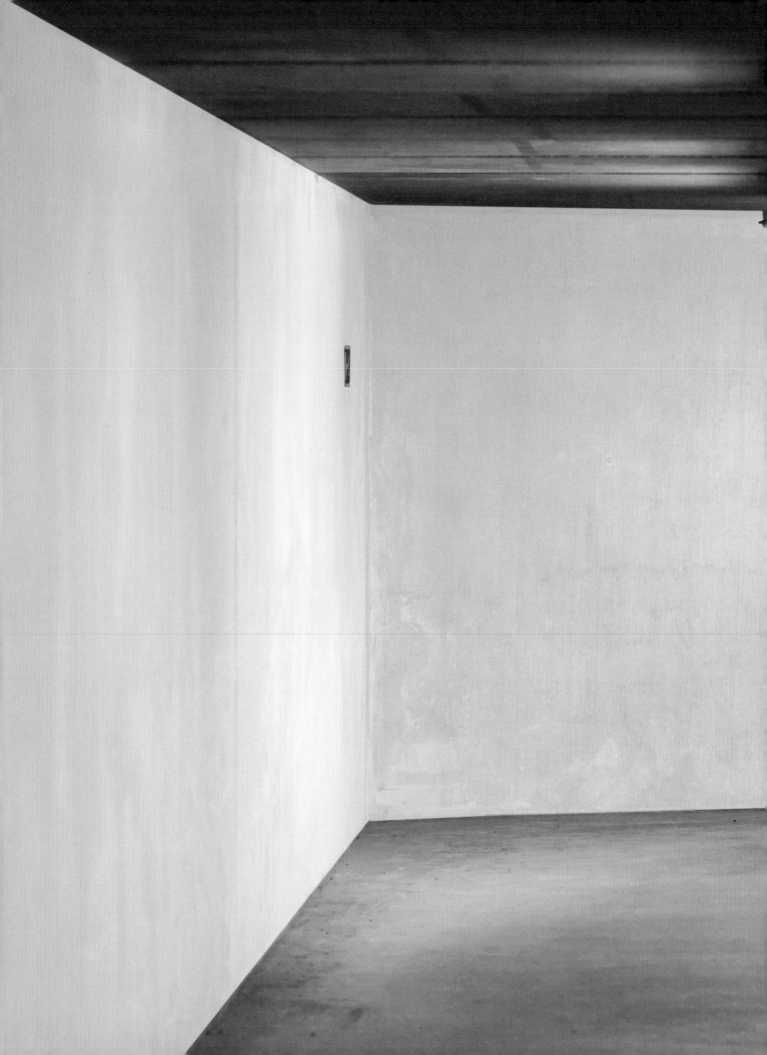

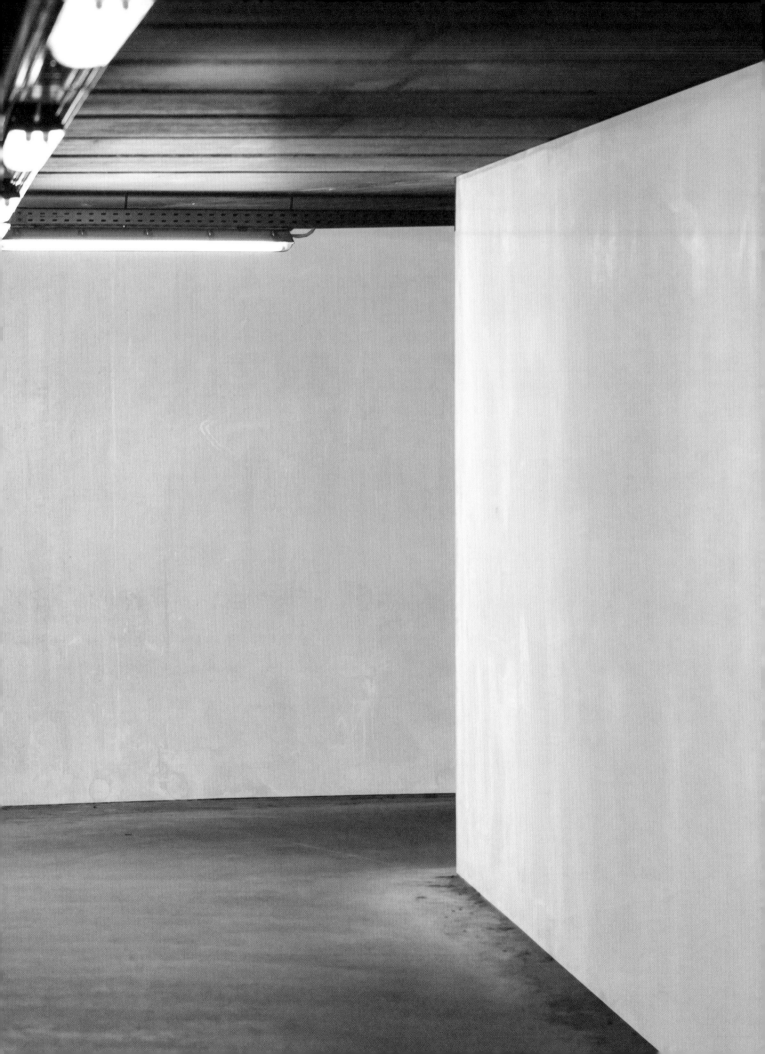

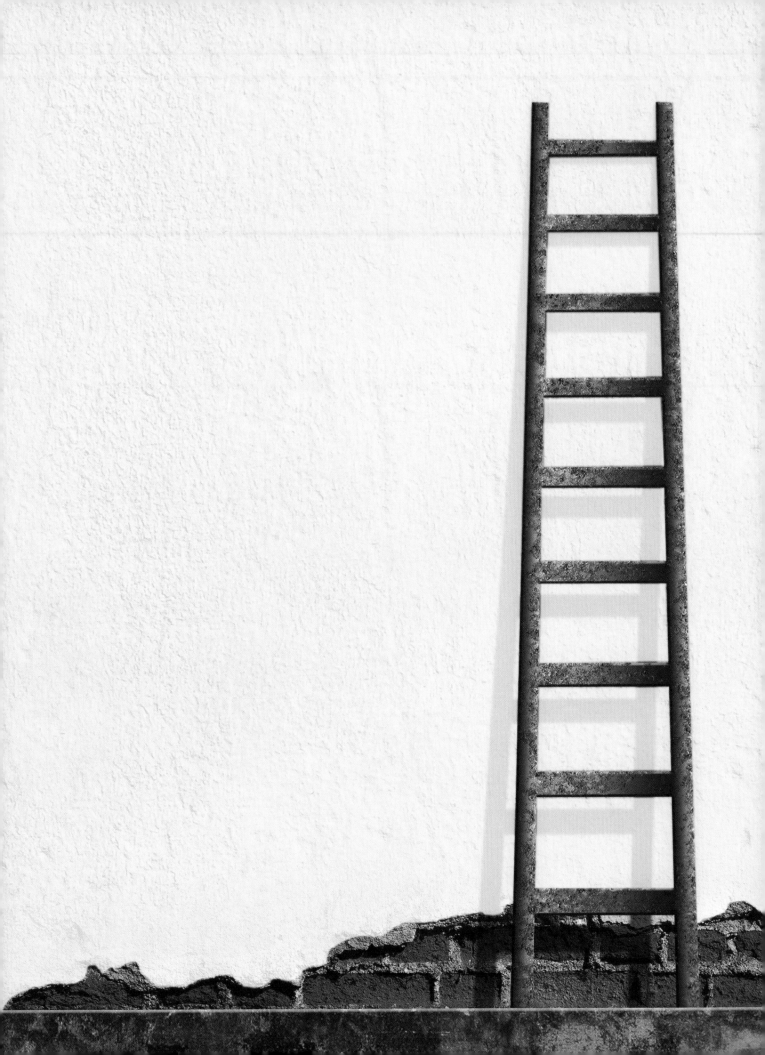

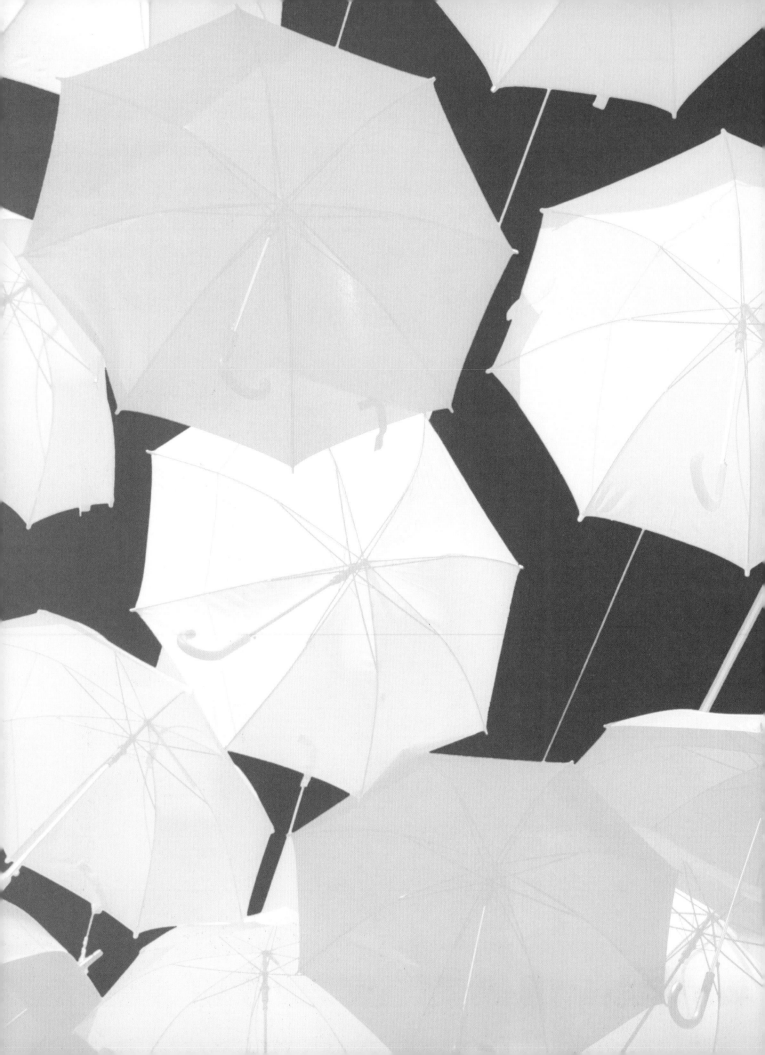

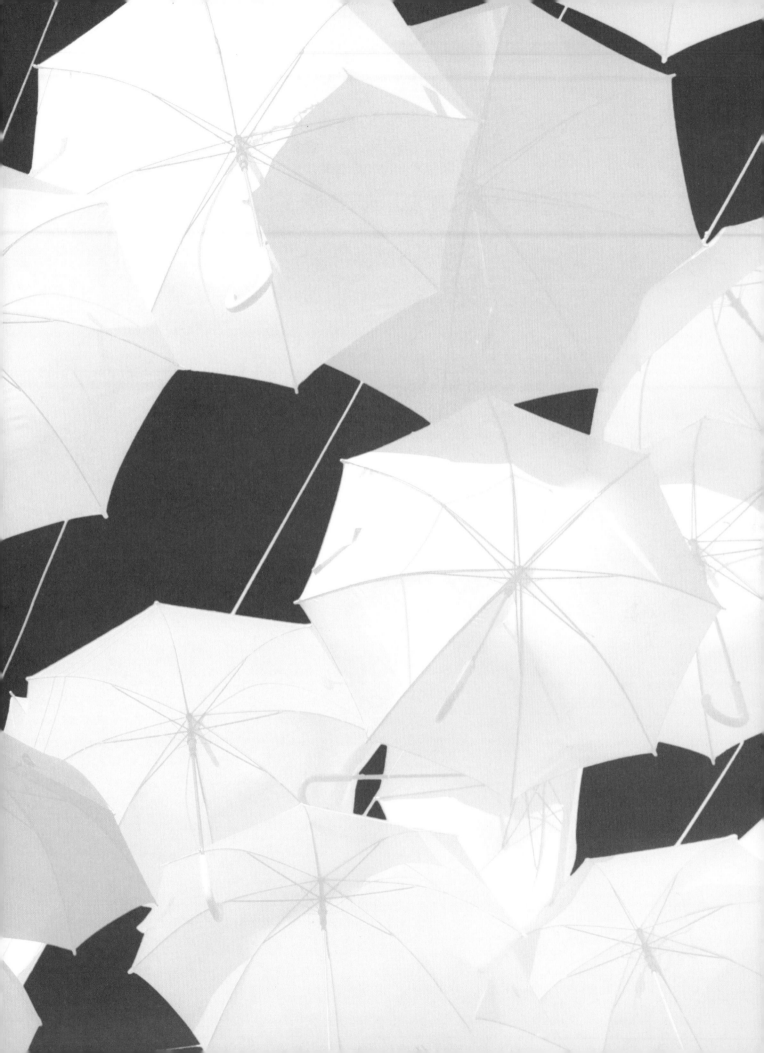